THIS JOURNAL BELONGS TO:

_____

INSIGHTS | Van Gogh Museum Amsterdam

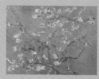

Vincent van Gogh,
*Almond Blossom*,
Saint-Rémy-de-Provence, February 1890,
Oil on canvas, 73.3 cm x 92.4 cm
Van Gogh Museum, Amsterdam
(Vincent van Gogh Foundation)

The Insight Editions x Van Gogh Museum collaboration elevates
everyday objects in unexpected and imaginative ways to make
the life and work of Vincent van Gogh known around the world.

Your purchase supports the work
of the Van Gogh Museum

© Van Gogh Museum

vangoghmuseum.com

INSIGHTS
www.insighteditions.com

MANUFACTURED IN CHINA
10 9 8 7 6 5 4 3 2 1